T0006025

FRIDA KAHLO

FRIDA KAHLO
THE LAST INTERVIEW
and OTHER CONVERSATIONS

with an introduction by HAYDEN HERRERA

MELVILLE HOUSE
BROOKLYN • LONDON

First Melville House printing: September 2020

Melville House Publishing 8 Blackstock Mews
46 John Street and Islington
Brooklyn, NY 11201 London N4 2BT

mhpbooks.com
@melvillehouse

ISBN: 978-1-61219-875-0
ISBN: 978-1-61219-876-7 (eBook)

Printed in the United States of America

3 5 7 9 10 8 6 4 2

A catalog record for this book is available from the Library of Congress.

CONTENTS

INTRODUCTION

FRIDA KAHLO: PAINTING COMPLETED MY LIFE
HAYDEN HERRERA

Frida Kahlo's interviews gathered in this book are intimate conversations. Her way of talking was as lively and direct as her painting. Similarly, when she spoke, she said whatever came into her head without trying to edit her thoughts and words. Kahlo could be hilarious, she could be ribald, and she could swear like a mariachi. She sometimes expressed herself with honesty that shocked. Her paintings, too, can be shocking. They are so personal, so full of agony, and often so bloody that viewers might draw back in horror before fully taking them in.

"I paint my own reality," Kahlo once said. Her art and life are so intimately linked that her work has been called an autobiography in paint. But her reality, no matter how straightforward its presentation, is always transformed by imagination. She charges actual moments with feeling and fascination by searching her core to find images that make reality more real than real. Kahlo's paintings dive so deeply into the personal that their message becomes universal. With uncanny force, they emblazon themselves on the mind and eye. For that reason, her art touches people all over the world. She has become an international cult figure. The so-called Blue House where Kahlo was born and died is now the wildly popular Frida Kahlo Museum. Frida's followers go there as if they were going to a temple.

Frida Kahlo was born in 1907 in Coyoacán, then a suburb of Mexico City. Her mother was a Mexican of mixed Indian and Spanish descent. Her father emigrated from Germany to Mexico in the late 19th century and became a professional photographer. Kahlo began the story of her life with *My Birth*, 1932, one of the bravest images ever painted. Her naked mother is shown from the viewpoint of the midwife. Her head is covered with a sheet because, Kahlo explained, while she was at work on this painting her mother died. The head of the child emerging from her mother's womb looks dead as well. Augmenting the anguish is a painting of the weeping Madonna of Sorrows, pierced by daggers, hanging on the wall above the mother.

The story continues in *My Nurse and I*, 1937, where Kahlo lies in the arms of her Indian wet nurse. "My mother couldn't suckle me because eleven months after I was born,

my sister Cristina was born. I was fed by a nana whose breasts they washed every time I was going to suckle." Frida has the body of an infant and the head of an adult because, she said, she did not remember her nurse's face. Of this, her favorite among her own works, Kahlo observed: "I came out looking like such a little girl and she so strong and saturated with providence that it made me long to sleep." To Frida, this image was consoling, in part because it showed her deep connection with nature and affirmed her passion for her native roots. Yet the masked nurse does not cradle Frida in a loving protective embrace. Instead, she embodies a cruel fatalism. Kahlo has taken the traditional Madonna Caritas image of Virgin suckling Christ and changed it to express her lifelong feelings of separation and loss.

In *My Grandparent, My Parents and Me*, 1936, Frida, who looks about three, stands naked in the patio of the Blue House holding a ribbon that supports her family tree. Above her are her parents, their portraits taken from their wedding photograph. In the sky above her father, her German grandparents float on a cloud. Above her mother are her dark-skinned Mexican grandfather and his paler wife. Kahlo was renowned for her wit and it must have been with a laugh that the she turned this family tree into a triple self-portrait. On her mother's wedding dress is Frida as a fetus and just below that is Frida's conception. Perhaps the loop of pink ribbon in Frida's right hand is meant to look like the vaginal source of all this procreation. Even the plant beside Frida's conception is spewing forth seeds.

Several paintings of Frida at about age four show her alone in a vast, barren landscape that makes her look vulnerable and very much alone.

When she was seven Kahlo contracted polio and was isolated in her room for many months. This solitude and confinement led to an expansion of her world through fantasy. By drawing a circle with the mist from her breath on her windowpane, she escaped to the underworld where she met a make-believe friend. While she was ill, a special closeness developed between Frida and her father, who, like her, was often sick. (He suffered frequent attacks of epilepsy.) He helped his daughter to recover by encouraging different forms of exercise. When Frida was well again, she tried to hide her withered right leg by wearing several pairs of socks, but the cruelty of children gave them sharp eyes. "Frida Kahlo Pata de Palo!" they cried. (*Frida Kahlo Peg Leg!*) This teasing intensified her feeling of being separate and different. Kahlo's bond with her father strengthened when she accompanied him on photography jobs. Her role was to help him during seizures and to make sure no one stole his camera. Back in his studio she learned to use small brushes with which she retouched his photographs. The eccentric and intellectual Guillermo Kahlo once said: "Frida is the most intelligent of my daughters. She is the most like me."

In 1922 Kahlo entered the prestigious National Preparatory School in the old center of Mexico City. That she was accepted testifies to her brains: she was one of thirty-five girls in a student body of some two thousand. She joined a group of brilliant, well-read, and extremely energetic boys who called themselves the "Cachuchas" after the caps they wore. With them she made mischief. Her personal mischief-making was focused on the famous and fat painter, Diego Rivera, who was at work on his first mural in the school's amphitheater. She

soaped the steps that led to the stage where he was painting, but Rivera, with his elephantine grace, never fell. Instead a professor fell down those stairs. When Rivera was working with a nude model, Kahlo would hide behind a pillar and shout, "Watch out Diego. Lupe is coming!" as if Rivera was about to be caught in some compromising embrace with another model. (Lupe Marín was soon to become Rivera's second wife.) Kahlo's schoolmates were horrified when she told them that her ambition in life was to have a child by Diego Rivera.

When Kahlo was eighteen and hoping to become a doctor, she was riding home from school on a bus with her boyfriend, fellow Cachucha Alejandro Gómez Arias. As the rickety bus turned a corner a trolley plowed into its side. The bus split in half and many passengers were killed or injured, among them Frida, whose groin was pierced by a metal handrail. Alejandro carried Frida and lay her on a billiard table in the window of a nearby billiard parlor. "I took off my coat and put it over her. I thought she was going to die," Gómez Arias recalled. The doctors at the Red Cross hospital where Kahlo was taken in an ambulance did not think that they could save her. Her spine was broken in three places, two ribs and her collarbone were broken, her right leg had eleven fractures, and her right foot was crushed. "In this hospital," Frida wrote to Alejandro, "death dances around my bed at night." Death would continue to dance around Frida. During the following two decades she had some thirty surgical operations. "I am disintegration," she wrote in her diary above an image of her disintegrating self.

Convalescing at home, she was "bored as hell" in bed, so her mother invented an easel that would allow her daughter to paint lying down.

Kahlo's first works were fairly conventional portraits of family and friends. She painted the first of her sixty-six self-portraits one year after her accident. The canvas is much too large to have been painted in bed. By now Kahlo had learned to walk again, but with a slight limp. Against a tenebrous sea and sky, Frida has depicted herself from the waist up. As in a photograph that her father took of her at this time, her head, atop an exaggeratedly long neck, turns to her right and one arm crosses her body. The portrait is both romantic and full of longing. It was painted at a time when Alejandro was pulling away from her. Her eyes beneath her joined eyebrows look at us as if she had a question. Her disproportionately large hand seems to ask the viewer to hold it. On September 28, 1926, she wrote to Gómez Arias, for whom the painting was to be a gift, telling him that his "Botticelli" was almost finished. "I implore you to put it in a low place where you can see it as if you were looking at me." Thus, from the beginning, Kahlo's self-portraits were a way of communicating her pain and of holding onto people.

In 1928 Kahlo took three paintings to show to Diego Rivera, who was now at work in his magnificent mural series in the courtyard of the Ministry of Education. She ordered him to come down from his scaffold and told him that she had not come to flirt. Rather she wanted his honest opinion about her work. Rivera admired her paintings and he admired Frida. She invited him to come to her home in Coyoacán the following Sunday so that he could see more of her work. A courtship ensued and Kahlo began to paint portraits of children such as *Niña* that were influenced by Rivera. *The Bus*, also from 1929, shows that Frida, like Rivera, wanted her art to

express her sympathy for the dispossessed. (Both Frida and Diego shared Marxist values even after Rivera was kicked out of the communist party in 1929.)

In August 1929, Frida and Diego were married. Frida's father, after warning Rivera that Frida would be a sick person all her life, accepted his future son-in-law, in part because he knew that Rivera could afford to pay Kahlo's medical bills. Frida's mother was more resistant. She was a devoted Catholic and she disapproved of Rivera's Communism and of his age (he was forty-one and Kahlo was twenty-two). It would be like "the marriage of an elephant and a dove," she said.

After marrying Rivera, Kahlo absorbed her husband's passionate *Mexicanismo*, a reverence for Mexico's native culture, its popular and pre-Columbian art that was shared by many artists, musicians, theater people, and writers after the Mexican revolution that ended in 1920. She began to decorate her home with Mexican folk art objects and pre-Columbian sculptures and to dress in Mexico's regional costumes, especially the full ruffled skirts and *huipils* (loose embroidered blouses) worn by the women of Tehuantepec. These costumes not only declared her sympathy for *la raza*, the people of Mexico, they also served to hide her limp.

Late in December the Riveras moved to Cuernavaca where Dwight W. Morrow, American Ambassador to Mexico, commissioned Rivera to paint a mural in the Cortés Palace and where Morrow loaned him his own house. In the following months Frida's mood saddened. She had a therapeutic abortion because her fetus was badly positioned. "We could not have a child," she wrote, "and I cried inconsolably but I distracted myself by cooking, dusting the house, sometimes

by painting, and everyday going to accompany Diego on the scaffold. It gave him great pleasure when I arrived with the midday meal in a basket covered with flowers." There were other reasons for her tears. Rivera, a well-known philanderer, did not mend his ways. Kahlo tried to be broadminded and to scoff at his infidelities, but they hurt. "I suffered two grave accidents in my life," she once said. "One in which a streetcar knocked me down . . . The other accident is Diego."

During the first half of the 1930s, partially because the reactionary presidency of Plutarco Elías Calles was inhospitable to leftist muralists, Frida and Diego spent much of their time in the United States. Rivera happily accepted commissions from capitalists. His aim was to bore from within. He hoped that his art would ignite a revolution, or at least prompt some Marxist impulses. The Riveras arrived in San Francisco in November 1930. By mid-January he was at work on his allegory of California in the stock exchange building. He was as infatuated with life in San Francisco as Kahlo was disdainful. "I don't particularly like the gringo people," she wrote in a letter. "They are boring and they all have faces like unbaked rolls . . ." She took refuge in work. *Frida and Diego Rivera*, 1931, is a sort of wedding portrait conceived a year and a half after the fact. The portrait gives a sanguine image of their marriage. But it hints at problems. Rivera, palette in hand, is the great *maestro* and Frida is his diminutive and adoring wife. His huge feet are firmly planted on the earth. The tips of Frida's pretty polka-dotted slippers barely brush the ground. His head is turned away from his wife. She cocks her head toward him and her right arm reaches so that she can place her hand in his. Early on, Kahlo recognized that her

husband was not possessable. "He never surrenders himself," she said. "He never was nor ever will be mine. He belongs to himself." Another time she put it this way: "Being the wife of Diego is the most marvelous thing in the world . . . I let him play matrimony with other women. Diego is not anybody's husband and never will be, but he is a great comrade."

Having arrived there in November 1931, Frida and Diego spent five months in New York. Rivera had to work hard to get ready for his retrospective at the Museum of Modern Art. Once again, Kahlo was disgruntled with what she called "Gringolandia." The Great Depression was in its second year and she was appalled to see the rich sipping cocktails while the poor stood in breadlines. "High society turns me off and I feel a bit of rage against all these rich guys here, since I have seen thousands of people in the most terrible misery without anything to eat and with no place to sleep."

When they arrived in Detroit in April 1932, she found the city to be "ugly and stupid . . . A shabby old village." Rivera was ebullient as he prepared to paint his murals on the theme of Detroit industry in the garden court of the Detroit Institute of Arts. He loved everything about machines. Kahlo did not. She was a month pregnant when she left Manhattan, and she was not feeling well. On July 4 she had a painful miscarriage. She hemorrhaged and was rushed in an ambulance to the Henry Ford Hospital. After being hospitalized for thirteen days, she returned to her apartment in the Wardell Hotel. To combat depression, she began to paint. It was as though pain propelled creativity. In this city that she loathed, she found her own language. From now on, her self-portraits were highly personal and full of fantasy. She was inspired by

Mexican *retablos* (ex-votos painted on small ten by twelve-inch sheets of tin, depicting a victim of disaster saved by the intercession of a holy image). Again mixing her art and her life of pain and miraculous survival, she borrowed not only *retablos'* medium and small scale, but also their simple narratives and their naive style. Her intimate self-portraits were the opposite of her husband's grand historical and political murals.

The first example of this radical new mode is *Henry Ford Hospital*, 1932, in which Frida lies naked and hemorrhaging on a hospital bed that floats in an immense empty plane. To underscore her feeling of isolation, she depicted the Ford's Rouge plant on the far horizon. It was here that Rivera was busy making studies of machinery for his Detroit Institute of Arts murals. Above and below Frida's bed are six symbols of miscarriage, each tethered to Frida by a red cord that suggests a vein or an umbilical cord. *Henry Ford Hospital* is revolutionary not only in its shockingly visceral subject matter but also in its portrayal of a nude woman, not from the male eye, but from the point of view of the woman inhabiting that nude's body.

From this time on, many of Kahlo's paintings express her sorrow at not being able to have a child. She painted herself accompanied by her pet cats, dogs, parrots, and monkeys. Even her still lifes and the tropical plants in the backgrounds of her portraits suggest her passion for fertility. The monkeys in particular seem to be substitute children, but they have a wildness that can be menacing. *Roots*, 1943, is a parturition dream in which Frida's torso is opened up to give birth to a vine that carries her life blood into the parched

Mexican earth. "My painting carries within it the message of pain . . . Painting completed my life. I lost three children . . . Paintings substituted for all of this. I believe that work is the best thing."

In March 1933 the Riveras arrived in New York and Rivera was soon at work in the lobby of Rockefeller center's RCA building on a mural entitled *Men at the Crossroads Looking Forward with Hope and High Vision to the Choosing of a New and Better Life*. Two months later, after he had inserted a portrait of Lenin into the mural, Nelson Rockefeller asked him to replace Lenin with an anonymous figure. Rivera refused and was fired. Nine months later the mural was chipped off the wall. While her husband was working on the mural, Kahlo was working on a small panel in which her Tehuana costume, without her in it, hangs in the middle of a composite image of Manhattan: skyscrapers, industrial chimneys, architectural monuments, and signals of gringo culture. Frida's dress is suspended on a ribbon attached to a toilet on one side and a sports trophy on the other. Further pictorial barbs at American values are a garbage pail overflowing with the detritus of conspicuous consumption, a telephone whose wire winds throughout the city, and a billboard of the voluptuous movie star Mae West, whom Rivera called "the most wonderful machine for living." Below Frida's empty dress are collaged images of breadlines, protests, and sports events. Above the dress is Federal Hall, its front steps replaced by a collaged graph showing "Weekly Sales in Millions." A ribbon winds around one of the Hall's columns and links Federal Hall to Trinity Church, in whose stained-glass window a dollar sign winds around a cross. In the distance is a ship that might be

a symbol of Kahlo's longing to return to Mexico. Center top is a tiny Statue of Liberty. Kahlo seems to ask, how much liberty can there be with so much poverty?

Kahlo was desperately homesick. Rivera wanted to stay in the United States because he felt that the Marxist revolution would happen in an industrialized country. In December 1933, Frida and Diego sailed home. Rivera was in a foul mood. He blamed his wife for making him leave New York. His health was poor. He was depressed and apathetic, and he was not working. Kahlo's health was bad, too. She had her appendix out, she lost another child, and her right foot was operated on. Rivera, perhaps in revenge, started an affair with the person Frida loved best, her younger sister Cristina. This was not a betrayal that Kahlo could take lightly. The Riveras separated for a few months and Kahlo painted almost nothing for two years. In 1935, in *A Few Small Nips,* she projected her own misery onto another woman's brutal murder. In this powerful but small painting, a man holding a bloodied dagger stands over his victim. The image is based on a newspaper story about a drunken man who, having stabbed his girlfriend twenty times, is brought to trial and protests, "But I only gave her a few small nips." Frida found this story both funny and painful, so painful that the blood spilled by the murdered woman could not be contained in the picture space. Splotches of red move out onto the painting's frame, which, in her rage and sorrow Kahlo stabbed in several places. She told a friend that she had needed to paint this scene because she herself felt "murdered by life."

In November 1934, Kahlo wrote to a friend, "I believe that by working I will forget the sorrows." With time, she forgave her sister and her husband. In July 1935, she wrote to Rivera that all his liaisons were only flirtations and that "at bottom you and I love each other dearly . . . I love you more than my own skin, and—although you may not love me in the same way, still you love me somewhat. Isn't that so?"

Two and three years later, Kahlo looked back on her unhappiness during Rivera's and her sister's affair and painted *Memory* and *Remembrance of an Open Wound*. In the former, she stands armless, her feet half on land and half on water, suggesting her feeling of being a divided self. Underscoring this falling-apart feeling, she has painted herself flanked by a schoolgirl outfit and a Tehuana costume, both outfits sporting one of Frida's missing arms and both hanging on hangers tied to ribbons that descend from the sky. Her foot is wounded and her huge extracted heart lies bleeding into the earth. Frida weeps as tiny cupids use the metal rod that goes through the hole where her heart has been torn out as a seesaw. In *Remembrance of an Open Wound* her foot is bandaged and she pulls up her skirt to reveal a long gash in her upper thigh, a wound that must refer to her injured sexuality.

In 1937 Rivera arranged for the revolutionary hero Leon Trotsky and his wife to be given asylum in Mexico, and Kahlo loaned them the Blue House in Coyoacán. Perhaps to retaliate against Rivera's infidelities, Frida had affairs of her own, one of them with the sculptor Isamu Noguchi and

another with Trotsky. After she ended the relationship, she painted a self-portrait that she dedicated and gave to Trotsky "with all love." The painting shows Frida at the height of her beauty, dressed fit to kill and standing, as do the figures in so many of the Mexican folk portraits that inspired Kahlo, between two curtains.

In 1938 the Surrealist poet and essayist André Breton came to Mexico and claimed Kahlo for Surrealism. Her response was, "I never knew I was a Surrealist till André Breton came to Mexico and told me I was. The only thing I know is that I paint because I need to, and I paint always whatever passes through my head, without any other consideration." Kahlo's fantasy comes not from Surrealism but from Mexican popular art and from her own active imagination. Kahlo did not paint melting clocks or oneiric visions. She painted things that actually happened to her. Even her most surrealistic painting, *What the Water Gave Me*, 1938, is not really Surrealist. It depicts her wounded legs beneath the bathwater. In her bathtub reverie memories float to the surface. "They thought I was a Surrealist, but I wasn't," she said. "I never painted dreams. I painted my own reality."

Thanks to Breton's recommendation, Julian Levy's Surrealist-oriented gallery in Manhattan gave Kahlo an exhibition in November 1938. In his preface to the show's brochure Breton called Kahlo's art "a ribbon around a bomb," catching both the charm and the explosive quality of her self-portraits. The exhibition had some good reviews and a few paintings were sold. In January Kahlo traveled from New York to Paris to attend an exhibition that Breton had promised to arrange. When she arrived, much to her annoyance, Breton

had not managed to get her paintings out of customs, nor had he found a gallery. She was also disappointed to find that her show was just part of a larger exhibition called *Mexique*, which included Mexican folk portraits, photographs by Manuel Alvarez Bravo, pre-Columbian sculptures, and objects of popular art that Breton and acquired in Mexico. It was Marcel Duchamp who extricated her paintings from customs and who persuaded the Pierre Colle Gallery to mount the show. Duchamp, Kahlo reported, is "a real guy . . . The only one who has his feet on the earth among all this bunch of coocoo lunatic sons of bitches of the surrealists." Kahlo found the Paris art world to be decadent and pretentious. Europe was, she said, "rottening." In spite of the threat of war, Kahlo's show was admired, but it was not a financial success. She made Rivera proud by selling a self-portrait to the Louvre. "There were a lot of people on the day of the opening," she wrote to a friend. "Great congratulations to the 'chicua' [one of Frida's nicknames], amongst them a big hug from Juan Miró and great praises for my painting from Kandinsky, congratulations from Picasso and Tanguy, from Paalen and from other 'big cacas' of Surrealism."

Upon her return to Mexico that spring, things were not going well in her relationship to Rivera. Possibly he had discovered her affair with Trotsky. By mid-September they had begun divorce proceedings, and by January 1940, the divorce came through. Rivera told the press that there was no acrimony, no trouble. The separation would be good for Frida, he said. She was young and he was old and had little to offer her. Later, in his autobiography he admitted: "I simply wanted to be free to carry on with any woman who caught my fancy."

Kahlo told a journalist that the causes of their separation were "intimate reasons, personal causes, difficult to explain." In her faulty but engaging English, she wrote to a former lover, "I have no words to tell you how much I been suffering and knowing how much I love Diego you must understand that this troubles will never end in my life . . . Now I feel so rotten and lonely that it seems to me that nobody in the world has suffer the way I do, but of course it will be different I hope in a few months."

During the year that Frida and Diego were divorced she painted some of her most powerful self-portraits. As in Detroit, pain propelled creativity. In *The Two Fridas,* 1939, one of only two large canvases that she produced, she sits side my side holding hands with herself. "The fact that I painted myself twice, I think, is nothing but the representation of my loneliness," Kahlo wrote to art critic Alfonso Manrique in October. "What I mean to say is, I resorted to myself; I sought my own help. This is the reason why the two figures are holding hands." *The Two Fridas* is, indeed, one of the loneliest paintings ever made. The Frida wearing the Tehuana costume is, she explained, the Frida that Rivera had loved. The Frida in the Victorian-style wedding dress is the Frida that he no longer loved. The Tehuana Frida holds a miniature portrait of Diego as a child and from its red frame springs a vein that passes through both Fridas' extracted hearts. The unloved Frida tries to pinch off this blood with surgical pincers, but the blood keeps dripping and transforms some of the red flowers embroidered on her skirt into red stains.

Another great painting from the divorce year is *Self-Portrait with Cropped Hair.* As she had when Rivera had his

affair with Cristina, Kahlo cut off her long hair and stopped wearing the Tehuana costume that Rivera adored. In this painting, she appears wearing a suit so large it must be Rivera's, and she holds the scissors that did the cutting as if she intends to continue destroying her femininity. Like the dripping blood in *The Two Fridas*, the shorn locks refuse to lie still. In Kahlo's self-portraits, there is no physical movement, but the paintings almost explode with rage and sorrow. With her typical black humor, Kahlo has turned her tragedy into an illustration of a popular song: "You see if I loved you it was for your hair. Now that you are bald I don't love you anymore."

During this period Kahlo's spinal problems worsened and she had to lie in traction for three months. Rivera, who was in San Francisco painting a mural on Treasure Island for the Golden Gate International Exposition, arranged for Kahlo to join him and to get medical attention. He put Frida holding a palette into his mural about Pan-American Unity in opposition to fascism. Frida, he explained, personifies the cultural union of the Americas for the south. He sits with his back to his ex-wife and holds hands around the tree of love and life with his current passion, the film star Paulette Goddard who, he said, represents "American girlhood . . . shown in friendly contact with a Mexican man." When asked why he was holding Goddard's hands, the incorrigible Rivera replied, "It means closer Pan-Americanism."

Frida and Diego remarried in San Francisco, after which they returned separately to Mexico. The remarriage had the same problems as the old one. Rivera kept on philandering and, as paintings like *Self-Portrait as a Tehuana*, 1943, reveal,

Kahlo continued to want to possess him even though she said she believed, as she put it, that the banks of the river should let the water run free. In 1949, when Rivera threatened to divorce Frida again because he wanted to marry the beautiful movie star María Felix, Kahlo painted *Diego and I*, in which her mask of imperturbability threatens to crumble. Her loose hair swirling around her neck echoes the inner turbulence that she tries to control. In the end, Rivera came back to Frida and she painted *The Love embrace of the Universe, the Earth (Mexico), Diego, me and Sr. Xolotl* (one of her hairless dogs). Although Frida is crying and her chest is cracked open, this is meant to be a celebration of love. Frida sits in the center like a Madonna holding not Christ but her baby Diego. Their love embrace is held together by a series of embraces. Frida now knew that the way to hold onto Diego was to treat him like a baby. "Women . . . amongst them I—always would want to hold him in their arms like a newborn baby."

From the mid-1940s on, Kahlo had numerous operations on her spine. In works like *The Broken Column*, 1944, she painted her response to this misery. Here her body is split open and her injured vertebrae are replaced by a broken ionic column. Nails driven into her flesh make her into a female Saint Sebastian. In spite of her tears, Frida's features refuse to cry. This stoicism is supported by her ferocious will. In *Tree of Hope*, 1946, painted after she underwent a spinal fusion, Kahlo appears twice, once as the helpless victim and once as the heroic sufferer transacting her own salvation, as she holds up a flag inscribed with the words of a popular song that she loved, "Tree of Hope Keep Firm."

After a year in the hospital during which she had some

seven spinal surgeries, Kahlo painted *Self-Portrait with the Portrait of Doctor Farill*, 1951, and gave it to her surgeon. Frida sits in a wheelchair at work on a portrait of her doctor. Her heart is on her palette and her brushes drip blood. This way she tells her doctor that she painted from her heart. "Dr. Farill saved me. He gave me back the joy of life." That joy was hard to hold onto. In 1953 her right leg was amputated at the knee. Ever gallant and full of bravado, Frida ordered red boots adorned with bells to "dance her joy." In her diary she drew her injured legs and wrote, "Feet, what do I need them for if I have wings to fly?" But she did despair. As her condition grew worse, she took large amounts of Demerol to ease her pain.

In April 1953, Kahlo was given her first exhibition in her native country, and she defied doctors' orders by having herself carried into the gallery in her own four-poster bed. There she lay, looking wild-eyed and ravaged, and receiving congratulations from a huge crown of friends and admirers. The following year, tied to her wheelchair, she was sometimes able to sit and paint for short periods. The narcotics that she took resulted in a loss of her delicate miniaturist technique. Her brushwork is rough and agitated in *Marxism Will give Health to the Sick,* in which she tried to make her art a vehicle for her political passions. Marx appears in the sky like a miracle-making saint in a *retablo.* Thanks to him Frida can cast aside her crutches.

The last image in Kahlo's diary is a chaotically brushed black angel. The last words are, "I hope the exit is joyful—and I hope never to come back—Frida." On July 13, 1954, Frida Kahlo died, probably from an intentional overdose. Rivera was distraught: "Too late now I realized that the most

wonderful part of my life had been my love for Frida." For those who love her painting, Kahlo is an example of strength in adversity, of the insistence on joy in the face of pain. In the last months of her life Frida Kahlo wrote in her journal:

> I have achieved a lot
> I will be able to walk
> I will be able to paint
> I love Diego more than I love my self
> My will is great
> My will remains.

Although Kahlo said that she wanted "never to come back," she loved life and lived it to its fullest. Eight days before she died, she wrote "Viva la Vida" on a succulent slice of watermelon in one of her last still lifes. "Viva la Vida" is a salute to life and an acknowledgement of the death's imminence. Even in her paintings of fruit and plants, Kahlo fused her art and life with such conviction and beauty that her paintings live on in us.

FRIDA KAHLO

WIFE OF THE MASTER MURALIST GLEEFULLY DABBLES IN WORKS OF ART

INTERVIEW BY FLORENCE DAVIES
THE DETROIT NEWS
FEBRUARY 2, 1933

Something about the hilarious incongruity of a stuffed lion, a plaster-of-Paris horse, and a colored chromo of George Washington draped in garlands of red, white, and blue crepe paper, all jumbled in the same shop window, proved to be too much for the sense of humor of Senora Diego Rivera, and so she simply had to do something about it. What she did was to go home and paint it, which may surprise people who think that Diego Rivera, the great mural painter now at the Detroit Institute of Arts, is the only artist in the family.

That, however, is all a mistake, since his wife, Carmen Rivera, or "Freda [*sic*]," as her friends call her, is a painter in her own right, though very few people know it.

"No," she explains, "I didn't study with Diego. I didn't study with anyone. I just started to paint."

Then her eyes begin to twinkle. "Of course," she explains, "he does pretty well for a little boy, but it is I who am the big artist." Then the twinkles in both black eyes fairly explode into a rippling laugh. And that is absolutely all that you can coax out of her about the matter. When you grow serious she mocks you and laughs again. But Senora Rivera's

painting is by no means a joke: because, however much she may laugh when you ask her about it, the fact remains that she has acquired a very skillful and beautiful style, painting in the small with miniature-like technique which is as far removed from the heroic figures of Rivera as could well be imagined.

Thus, while her husband paints with large brushes on a huge wall surface, his wife, herself a miniature-like little person with her long black braids wound demurely about her head and a foolish little ruffled apron over her black silk dress in lieu of a smock, chooses a small metal panel and paints with tiny camel-hair brushes.

In Detroit she paints only because time hangs heavily upon her hands while her husband is at work in the court. So thus far she has finished only a few panels. The window of the shop where street decorations are manufactured was obviously done in the spirit of humor. A little more seriousness, however, has gone into a portrait of herself standing on the borderline between Mexico and the United States.

In the center of the picture, standing on a little gray stone bearing her name and date, is a full-length portrait of herself clad in a charming pink frock, with long lacy mitts, and holding a tiny little Mexican flag. In the background are, on one side, the tall chimneys of American factories and the roofs of skyscrapers, while on the other, the ruins of old Mexican temples with the fruits and vegetables of Mexico in the foreground on the one side and small bits of machinery representing this modern world on the other side.

"But it's beautifully done," you exclaim. "Diego had better look out."

"Of course," she cries, "he's probably badly frightened right now;" but the laughter in her eyes tells you that she's only spoofing you—and you begin to suspect that Freda believes that Diego can really paint.

RISE OF ANOTHER RIVERA

INTERVIEW BY BERTRAM D. WOLFE
VOGUE
NOVEMBER 1, 1938

A newcomer to the art galleries of New York is Carmen Frida Kahlo de Rivera, wife of the weighty and mighty Diego, the master painter of Mexico. She is now having her first American showing at the Julien Levy Galleries.

About this exhibit, she wrote:

> I have never had an exhibition before. I was always shy and afraid to show my things. The first time in my life I sold a work was a few weeks ago to Edward G. Robinson. I gave as a present three or four paintings to people I like, and that is all. I never knew I was a Surrealist till André Breton came to Mexico and told me I was. The only thing I know is that I paint because I need to, and I paint always whatever passes through my head, without any other consideration.

Those words give a clue to Madame Rivera's personality and to her paining, for she is one of the most spontaneous and personal of artists. Though André Breton, who will sponsor her new show in Paris, told her she was a *surréaliste*, she did not

attain her style by following the methods of that school. Nor is she influenced by her husband's manner in her work. Quite free, also, from the Freudian symbols and philosophy that obsess the official Surrealist painters, hers is a sort of "naïve" Surrealism, which she invented for herself. Here and there, as in *Fulang-Chang and I*, there seems to be a trace of the Douanier Rousseau, but even that influence may be accidental. It was not from other painters, nor from schools, but from within herself that she derived the matter and even the manner of her painting. Boredom and suffering during a year spent flat on her back in a plaster cast, after an automobile accident, made a painter out of her; and each of her paintings since has been an expression of a personal experience. Even when she does not herself appear in a canvas, she somehow pervades the picture.

Little more than half as old as Diego Rivera, she is his third wife, and on good terms with both her predecessors. In fact, she had done a portrait of Lupe, the wife she succeeded. But that was one of her earlier and less interesting works. Each of Rivera's former marriages went on the rocks during its seventh year, and, in the same fateful seventh year, Madame Rivera's marriage also came near suffering shipwreck. A lonely and miserable time followed for both of them—recorded in her *Self-Portrait with Heart*, shown here—but that quarrel ended with a deeper understanding and greater mutual dependence.

They first met in 1922, when Frida Kahlo was a dynamic, mop-haired little nuisance at the National Preparatoria School. She was thirteen, a tomboy, ringleader of a gang of boys and girls who made the school halls ring with their escapades. And Rivera was thirty-six, and had come to the Preparatoria

to do his first Mexican mural. In the heavy painter, she found a particularly promising target for her pranks. Hopefully she soaped the stairway down which he had to descend from the auditorium stage. Then she hid behind a pillar. But the slow, work-weary painter didn't even slip. But when, on the following morning, the director fell down the stairs at assembly time, she felt that the soap had not been wasted.

So many and wild were her plots that eventually the director expelled her. But the Minister of Education himself, moved by her disarming appearance and scholastic record, ordered her reinstatement. "If you can't manage a little girl like that," he said to the head of the school, "you are not fit to run an institution!"

Not content with such minor pranks, she then began interfering with Rivera's love affairs. He was, at the time, courting Lupe Marin, soon to become the second Mrs. Rivera. It was Frida's delight to hide near the door. When she saw the beautiful model coming, she would cry out, "Look out, Diego, here comes Lupe!" as though Rivera were entertaining a woman visitor.

One day, when she and some classmates were discussing their plans, she calmly announced, "My only ambition is to have a child by the painter Diego Rivera." Her girlhood desire to become a mother became almost an obsession with her. Indeed, it is the subject of many of her paintings and colors the mood of a number of them. The most striking is the self-portrait dealing with childbirth, which gives a clue to her unhappy obsession.

So intimate in their import are her paintings, that we could easily reconstruct her life and personality from them. There is a

picture of hers called *My Family*, which shows her parents and grandparents (arranged in the form of an amusing family tree). In this painting, there is also a number of playful self-portraits— Frida before she was born; Frida as a nude little girl.

CHILDHOOD MEMORIES

Remembering the time when her parents dressed her in a white robe and wings to represent an angel (wings that caused her great unhappiness because they would not fly), she painted her charming *Girl with Airplane*. Another childhood memory is celebrated in the strange painting, *I and My Nurse*. But, as childhood memories are often distorted by the experiences of later life, she has painted herself in her Indian nurse's arms, with a child's body, but her present adult face. Her *Portrait of Diego* is revealing, not merely as the likeness of the celebrated painter, but for what it tells of her feeling for him. Only the eyes of love could create this romantic and curly-haired version of the man.

While official Surrealism concerns itself mostly with the stuff of dreams, nightmares, and neurotic symbols, in Madame Rivera's brand of it, wit and humor predominate. Even her saddest experiences become a subject for laughter. This is attested by the little angels playing seesaw on the stick that pierces the empty place where once was her heart. There is the sly stressing of resemblance between her own features and those of her pet monkey in *Fulang-Chang and I*.

She seems to come closest to Surrealism in those of her paintings which deal with accident, disaster, and death, but

they come rather from a deep-rooted Mexican tradition, as does her favorite medium—oil on tin—in which she paints.

In her imperfect English, she wrote a friend a few facts about herself:

> Here it is all my "important" history. I was born in Coyoacán the 7th of July of 1910. My father is German, my mother Mexican. I never thought of painting until 1926, when I was in bed on account of an automobile accident. I was bored as hell in bed, with a plaster cast (I had a fracture in the spine and several in other places), so I decided to do something. I stoled from my father some oil paints, and my mother ordered for me a special easel because I couldn't sit down [ED: she means "sit up"], and I started to paint. Before that accident, I was in the preparatory school. I wanted to study medicine.
>
> When I recovered more or less, the doctors didn't allowed me to come back to school. So I could paint all the time. Diego was painting in the Secretariat of Education, and I went often to watch him. Once I took my three first painting to show him. He liked them quite well.

From the bright, fuzzy, woolen strings that she plaits into her black hair and the color she puts into her cheeks and lips, to her heavy antique Mexican necklaces and her gaily coloured Tehuanan blouses and skirts, Madame Rivera seems herself a product of her art, and, like all her work, one that is instinctively and calculatedly well composed. It is also expressive—expressive of a gay, passionate, witty, and tender personality.

RIBBON
AROUND BOMB

INTERVIEW BY GEOFFREY T. HELLMAN
AND HAROLD ROSS
THE NEW YORKER
NOVEMBER 5, 1938

The Julien Levy Gallery sent us an announcement in which André Breton said that Mrs. Diego Rivera's painting was like a ribbon around a bomb, and spurred by this, we attended the preview of her show last week. She was sitting at one end of the gallery in a brightly colored Tehuantepec costume, looking pretty much like a beribboned bomb herself. She is dark, small, vivacious, and twenty-eight, twenty-four years younger than her husband and two hundred pounds lighter. Diego, who is in Mexico City, lost a hundred and twenty-five pounds doing the Rockefeller Center frescoes but has since gained most of it back. Mrs. Rivera told us she likes him better fat. She says she met him that way and thinks of him that way.

Mrs. Rivera paints under her maiden name, Frida Kahlo. Her father, a photographer, was born in Germany. She has painted since she was sixteen, when she was injured in an accident and had to spend several months in bed. A couple of years later, Rivera, after looking over her paintings carefully, married her. Most of the pictures at her exhibition are of herself. One shows her with her hands cut off and an enormous bleeding heart on the ground. On either side of her are two

empty dresses. She explained to us that this was how she felt when her husband went off on a trip for a while a few years ago: she felt only half there. "Diego liked the painting but he didn't think much of the idea," she said. "He's not very sentimental." A couple of other Kahlos give a good deal of prominence to the artist's toes. Mrs. Rivera said the reason for this is that her toes have troubled her ever since her accident and are on her mind. While we were talking to Mrs. Rivera, a large number of social people and several Trotskyites strolled about sipping sherry, including Mrs. Cornelius Bliss, A. Conger Goodyear, Suzanne La Follette, Buckminster Fuller, Meyer Schapiro, Mrs. Henry Luce, Mrs. Roger W. Straus, and a female photographer representing "*Life* Goes to a Party."

Mrs. Rivera is accompanied by her younger sister, Christina, who came here to see the five-and-ten-cent stores and does so extensively. Christina wears conventional clothes, but Mrs. Rivera sticks to the Tehuantepec costume and got asked if she was a fortune-teller when she was on the subway the other day. She makes the velvet frames which go around many of her paintings. Walter Pach was the first to buy a painting at the exhibition. It is called *Survivor* and consists of a Mexican idol looking lonely on a large field. This symbolizes the survival of Mexico in a shaky world. While we were there, Mrs. Sam Lewinsohn bought No. 6, one of the few still lifes in the show, and asked Mrs. Rivera to lunch on Sunday.

We asked Mrs. Rivera about No. 20, which is called *Passionately in Love* and is a definitely macabre piece of business. It shows the nude body of a murdered woman with the murderer standing above it. Mrs. Rivera got the idea from a trial she read about, in which a wife-killer said to the judge, "I

just gave her a few pinches." "No one will buy this," said Mrs. Rivera. "Everybody gets scared." No one seemed to be buying No. 1, either. It shows Mrs. R. holding a note wishing happy birthday to Leon Trotsky. Trotsky is living in the house in Mexico City in which she was born. She says he spends most of his time gardening, fishing, and shooting squirrels.

"FRIDA: LANDSCAPE OF HERSELF"

INTERVIEW BY MARIO MONTEFORTE TOLEDO
NOVEDADES: MÉXICO EN LA CULTURA
JUNE 10, 1951
TRANSLATED BY VIVIAN ARIMANY

Translator's Note: The source material for this translation was damaged and some of the words on the first page are missing. The words in brackets are my attempt to determine these words. I have done my best in maintaining the intended meaning.

Simple and complicated, like a candlestick from Metepec. Just as rudimentary, just as delicate, just as Mexican, just as universally popular is Frida Kahlo, a well-established figure in contemporary art.

Her critics speak of her [pain] as well as her strength [to overcome it]. They speak of her frustrated maternity, of how much of an inspiration she is to the [famous] man who is her husband. It is difficult to [isolate] her visceral, deeply dramatic artwork from the life that produced it—for this is one of the few cases in which an entire life completely originates from art.

Regardless, there is much more to say on this joven abuela, the decoder of a hidden Mexico and of that microscopic space where intimacy occurs for humans, things, and every visible subject.

She has painted many self-portraits. Many are familiar with the one of her head which, through the fine neck of a brown woman, seems to distance itself from its body. The eyebrows, groomed to resemble a swallow against a stormy firmament, accentuate this beautiful message: the voracious eyes, half-oriental, somewhat fearful, like those of primitive people; the repulsed, sensual nose; the unsmiling, girlish mouth; the smooth skin, youthful without vaunting opulence. A monumental head that sometimes completes corporeal thoughts. Lately, Frida has followed her own path, which has increasingly grown concrete and real.

Frida Kahlo's art emanates from two places: an insatiable curiosity for material and an innate talent for superstructure and composition. Natural elements are carefully investigated and reproduced, but the main idea of the composition is a general rearrangement of nature, an avoidance of each of its unimaginative laws. There's no wonder why [Pieter] Bruegel, [Matthias] Grunewald, and [Hieronymus] Bosch are among her preferred painters. The surrealists will say her work is surrealism, but Frida begs to differ due to both the ideology and the meaning of her work. She does not commune with [Salvador] Dalí, with [Kurt] Seligmann, or any of the others who claim Bosco as their predecessor. For different reasons, she admires Piero della Francesca, [Paolo] Ucello, Clué, and [Pierre-Auguste] Renoir, and others who resemble her work, such as [William] Blake, [Paul] Klée, and Marcel Duchamp. The only female painter who interests her is Leonora Karrington *[sic]*.

"Has any painter influenced you?"

"I don't think so. The only one who has taught me

painting is Diego, without ever placing any ideas in my head, or telling me what I should or should not do. Because, I think, we are different."

She is a muralist and an anti-muralist.

Besides, she has never resembled anyone, or almost anyone, since she began to paint at age seventeen, without a background or training, just because she found a box of her father's oil paints in a corner. She became familiar with the retables that many consider crucial to her compositions later on, after she was already making miracles on her own, assembling her Mexican colors with naïve magic.

Unintentionally, her paintings are filled with tension; to such an extent that they sometimes prevent the collapse of even the most crumbled scaffoldings, and in almost all of them there is a poetic symbol, gently isolated, like in the canvases of both [Marc] Chagall and [Rufino] Tamayo. Next to a tangle of cardinals and limes where spiders and all those gaunt highland insects alight, a small pigeon or chick appears to free itself from the torment due to its candor, being harmless and unarmed.

This artist's life occurs in small jumps, like plaques illuminated by a fervent light. She passionately takes time for each moment and each thing, as if something transitive was the most important thing on Earth. She is not preoccupied by hope, nor is she informed by memory.

"But, haven't you memorized a poem? Or sentence?"

"Nothing. The poet I like the most is [Carlos] Pellicer. I also admire Pita Amor. As for foreigners, [Walt] Whitman. But I haven't memorized anything; not even the national anthem."

She also writes. Strange things filled with the arcane, surrounding the faces and voices that appear on the other side of an open window and then disappear. Without explanation, the protagonist—almost always a woman—remains in the center of the absences, of what could be, of all that is not a dream—because Frida never dreams—but this is better than a dream because you can arrange and dress it in colors. All of this is written in her diary in various senses, in almost vertical handwriting with closed vowels and irregular heights.

She is surrounded by a collection of objects. Even the most minuscule of things awakens her curiosity, as if they were obtainable stars: pencils, stones, leaves, ceramics, and even rings fill her fingers like offerings.

"Why do you wear those?"

"Because they look pretty."

I wonder what this woman, like a cenote, filled with speculation and endearing life, would like to be.

"A biologist; a naturalist."

I do not doubt this for a second. Her paintings prove it: in the loving care with which even the most humble forms are painted; in her cortical preoccupation, revealing the warmth of entrails and membranes; in the ligament between veins and trees, between feet and corpses, that germinate underground, like a portrait by the naturalist Burbank; in her architectural notion of the body, like in the impressive "broken column," where half of her appears wrapped in a fine bandage, with a crumbling ionic column in place of her spine; or in the Pantagruelian reminiscent of birds, pigs, and cows without skin, that squeeze together in a bloody mass, similar to one of her most striking self-portraits, which she

painted in a hospital bed when a doctor optimistically announced, "You can eat anything."

On the back of this painting's frame, one can read the lines: "I no longer have even the / slightest hope . . . / It all moves to the beat of / which my belly holds." – F. K.

Her fascination with substance is infinite. In one of her most important oil paintings—surely one of the best portraits ever made in Mexico—the old woman Mrs. Briones Morillo is silhouetted against a background of elongated cacti, lavished with the small purple flowers Frida so loved. This painting is a treatise on an intimate living subject, heavy with an eloquence that only an artist of wisdom and patience can unravel.

"Is that one your favorites?"

"No. I prefer *My Nurse and I.* I came out so childish and she is so strong and saturated in providence that I wanted to sleep."

In spite of these images, Frida Kahlo's paintings never cease to suggest something magical. Even the background surrounding the principal figures tends toward extravagance, with its scowling rocks, its bitter flowerings, and its crevices. A painter's background, minerals at the service of the imagination.

This painting does not indicate automatism of any kind, nor a brain troubled by the sort of clinical study that can expose you with bleak punctuality, neither imprecation nor denigration. On the contrary, the painting proclaims triumph over the flesh, over material that is closely known, and over a particular notion of the world, it speaks to a magnificent, organic creator. This world boils in her hands, in

her thoughts, in what she hastily tells friends who hold up their fabulous indigenous garments, like tourists from distant stars; in what she imagines is done and felt, although no one puts it into words or action. This is her harmless little game; the grand form of her love for humanity that interests her and roots her destiny.

This is Frida Kahlo, with her mocking monkey, her millenary Mexican dog and her god without language, part destroyer and part creator.

"A PICTURE OF FRIDA KAHLO"

INTERVIEW BY GISÈLE FREUND
NOVEDADES: MÉXICO EN LA CULTURA
JUNE 10, 1951
TRANSLATED BY VIVIAN ARIMANY

"I have suffered two serious accidents in my life," says Frida, without ceasing to paint. "One where a tram hit me when I was sixteen years old: spinal fracture, twenty years of immobility . . . The other accident was Diego . . ."

Despite her suffering, Frida maintains her sense of humor and faith in life. We are in the studio of her home in Coyoacán. Every time I visit her, I feel as if I am in a fairy tale. The large room is filled with pre-Columbian artworks from Diego Rivera's collection, and numerous objects of Mexican folk art, so rich in colors, shapes, and ideas.

"Actually, Picasso didn't invent anything," I tell Frida, while looking at the huge Judas Diego has placed in every corner of the room. The whole house breathes art and the love of art: it reflects the sensibility of those who inhabit it.

I take a look at the small painting that Frida is finishing. It portrays Frida herself, seated in a wheelchair, upright, solemn, dressed in a simple huipil from Yalalá and a wide petticoat that falls to her feet. In one hand, she holds a palette, in the form of a heart with its multiple arteries and nerves. In the other, the brushes: the drops of paint that fall from

them are blood. Next to her portrait, on a miniature easel, is
the portrait of Dr. Juan Farill. The colors are sober, the com-
position ingeniously simple and wonderfully balanced. The
picture does not measure more than fifty by sixty centimeters.

Whenever I'm in front of a Frida Kahlo painting, a pro-
found emotion squeezes my heart. An emotion that not only
arises in me for the perfect quality of her art but also for its
message.

This small picture Frida has already finished reflects the
human condition in stunning fashion. With a bare heart and
bleeding brushes in her hands, Frida is not only a symbol
of humanity as a whole, placed in front of the science of
man's thought and the perfection of his spirit, which we all
expect—here personified as the eminent doctor—will free us
from our human condition: although at the same time, man-
kind's genius has created the forces that hound him, ready to
destroy him.

She simply paints her own vulnerability. Frida, fragile
but brave, fully aware of all the difficulties life throws at her,
is ready to fight. And she will win. Just as the forces of hu-
manity that fight for a better future will win. In this little
painting, Frida's fate identifies with mankind's destiny. Al-
though alone in her giant house, her illness prevents her from
going out, all of humanity walks through her as if along a
great path.

There are those who have criticized Frida Kahlo for the
repetitive theme of her paintings. They have said: "Why do
you always paint yourself? Why don't you paint the Mexican
people?"

Every artist is the expression of their time, whether they like it or not. The artist cannot create anything other than what he himself has experienced.

"What do you think is the greatest truth that a human being can have?" I once asked Frida.

"Being faithful to yourself," she replied.

And, in effect, the more faithful an artist is to themselves, the better they will reflect the concerns of their time. Thus, it can be said: the greater an artist's genius, the better their work exposes the problems of their society. Artists have more sensitive and receptive antennas than most men: they are the first to perceive and express the concerns of their time.

As for me, a European who has never denied her deep love for Mexico, I confess that Frida's paintings have been able to explain to me more about these people, their problems and their aspirations, than the work of any other Mexican painter. Precisely, Frida Kahlo's work raises not only the problems of Mexico but also the problems of all people on earth.

The value of an artist is not defined by the amount of work done. Frida has not painted many canvases. Neither did Rimbaud write many poems, but he is one of the greatest French poets. Similarly, I consider Frida's art as one of the most authentic and profound expressions of current Mexican art.

"FRIDA KAHLO: AN AESTHETIC INVESTIGATION"

INTERVIEW BY PAUL WESTHEIM
NOVEDADES: MÉXICO EN LA CULTURA
JUNE 10, 1951
ORIGINALLY TRANSLATED FROM ENGLISH TO
SPANISH BY MARIANA FRENK
TRANSLATED BY VIVIAN ARIMANY

A remarkable painter, a creative artist, among the many men and women who are trained, skillfully and diligently, to vary what is being painted—and how it is painted—in the current moment. In the history of art, in museums, on the walls of private collectors, they occupy the greatest place. They are the kind talents, they are the ones who "have a lot of ease painting," and large sectors of the public revere and admire them. The others—Frida Kahlo belongs to the others.

Among her qualities are her pictorial facture, her trade, subtle and expressive, a palette rich in gradation, that brings to the eye a sensual joy. When Frida Kahlo paints flowers, they are not those decorative stylizations that serve to fill a frame. Frida Kahlo's flowers unfold in the pictorial space, bloom in the vibrations of her colors, and through color suggest their fragrance.

A human battered by spiritual experiences, a magical mood, very much her own, that struggles to emerge from arcane depths to consciousness, in order to become a second, imaginary personality, or perhaps more real than the other, that is ready to expel at moment. Frida Kahlo sees visions.

And Frida Kahlo has the gift to give her visions pictorial expression. Her work is a visual experiment, not mere empirical fantasy—like many of [William] Blake's English paintings. The subconscious becomes an image expressed in a language that not everyone can read, only those who have made a pact with spiritual beings.

Just as there are painters who turn a sharply observed reality into a dream of unreal beauty—[Johannes] Vermeer was one of them—Frida Kahlo manages to turn her fantastic, unreal dreams into an artistic reality through the spell bestowed upon an artist—if he is more than just a professional painter—by the magician who carved amulets for the tribe.

Frida Kahlo does not belong to any school, to any trend, to any movement. She lives in the margins. She is an artist who depicts her visions and fantasies. Perhaps what compels her to create is the need to expel these fantasies and visions that harass, distress, and torment her. The silent language of painting is a scream for her. It is scream and sublimation and catharsis all at once. It makes us think of [Francisco] Goya, the Goya of the "Caprichos"* that cover the walls of the Quinta del Sordo with the ghouls of a boundless fantasy that anticipated Freud by a hundred years prior.

Frida Kahlo's paintings represent the twentieth century. Those artists "willing to complete the tasks of their time," are locked in their concrete tower furnished with programs and ideologies—compared to the ivory tower that is open to the great air—are perhaps shaking their heads as they read this. Those creations could only be formed by an artist of

* A series of prints in aquatint and etchings Goya produced in 1797 and 1798.

our century whose imagination is seeped with the spiritual currents of the time. The little there is of Freud, of surrealism, or of magical thought in Frida Kahlo's painting is surely not assimilated through reading but natural, from her own way of living in the world. This manner of pictorial expression has been encouraged by the same artistic approach that produced Paul Klee, Juan Miró, Max Ernst, and others who we have accepted as a starting point for artistic expression in our times. When [Gustave] Courbet heralded realism integral, when [Claude] Monet trained the eyes of his contemporaries to enjoy the phenomena of color and light, in that bygone art world Frida Kahlo's work would have been categorized as bizarre and absurd; perhaps it would never have been possible. The contemporaries did not understand Goya's "Caprichos" either, only that respect for the great master made them tolerate his painted nightmares, like the unexplained symptoms of old age.

The title of one of her paintings is "The Two Fridas." One is the Frida who lives in Coyoacán; who sometimes appears next to Diego meetings, dressed in her regional costume. She is—as many times before—lying in a sanatorium bed, to restore the health of a body battered by indiscriminate fate. The other is the Frida of fantasies, of life and death anguish, of dreams and visions.

• • •

Frida Kahlo's art is feminine in a specific sense. In an article published by the *Boletín del Seminario de la Cultura Mexicana*, Diego writes: "Frida is unique in the history of art, ready to

tear her breast and heart to speak the biological truth of what she feels inside them . . . She is the only woman who has expressed in her works of art feelings, functions, and the creative power of women, with unsurpassed *Kalis-Teknika*." Her whole being revolves around two central points, all her feminine feelings: love, her love for Diego, and for the childbirth that the real Frida has been denied and the other Frida lives in her fantasy with passionate emotion.

She painted a picture with two backgrounds, in which the two components of her ideological and sentimental worlds are intertwined in one magical work. Diego, resting in her bosom, at once a man and a child. In the background, the goddess of the earth, the sun—fertilizer of the earth in the myth of ancient Mexico—and the moon, which protects the growth and ripening of the seeds. [The] Symbol of the Universe, that here, in this canvas, springs from a womb. She paints with an insight that I would describe as surreally real, her own birth; Frida emerging from her mother's womb, like Xolotl emerges from the womb of a sea shell in a drawing in the Codex Borgia, a symbol of birth and fertility. A few years ago, the engineer José Domingo Lavin suggested that Frida paint a "Moses" based on Freud's book, that problematic book in which a profound spirit was seduced by a whim. Frida Kahlo did not paint the biblical Moses, but neither did she paint Freud's. What incited Frida's imagination was the legend of Moses's birth, the newborn in the basket that the waves carry to the beach, the princess to whom he is given by the Nile, giver of life in ancient Egypt. In Hebrew "Moses" means "he who was taken from the waters." Perhaps what excited her about the legend was not the miraculous salvation

of the child, but the miracle experienced by the daughter of the pharaohs when she found among the reeds that infant she could mother and care for. She may have been moved by Freud's explanation of the word "basket." "Basket—she explains—is the exposed womb and water represents the maternal source giving birth to an infant." Frida paints an adolescent Moses, the hero called to give mankind the concept of a singular God, framed as a child, by the great spiritual heroes of all time, of all peoples, of all ideologies. She does not paint an interpretation of Moses; what she paints is her own experience, just like everything Frida Kahlo paints.

• • •

"What I wanted to express, more intensely and clearly," she said in a talk where she tried to explain the meaning that guided her creation of this great work, "was that the reason people needed to invent or imagine heroes and gods is pure fear. Fear of life and fear of death."

The mystery of life, that captivates the gaze of man like the petrifying face of Medusa, is the subsoil in which Frida Kahlo's creation is rooted and gives her work a fourth dimension, that of the human and spiritual. The primordial anguish of the human creature, so fragile, so ill-equipped for the immense, the ineffable that is our existence between birth and death; the miracle, renewed again and again, for her—woman—is to love and give birth.

And let's not fail to note that the enigma of existence is not conceived, as by [Albrecht] Dürer and many others, from death, but femininely, maternally from birth.

• • •

It is evident that a path of retables—that original manifesta-
tion of Mexican popular art—leads to Frida Kahlo's style. Ro-
berto Montenegro, who has a sort of sixth sense for someone's
specific inspiration, says in his recently published book, *Reta-
blos de Mexico*: "We see the naive and sentimental alternate on
a plane of anecdotal tragedy, unconsciously making a genre of
painting that reaches the boundaries of surrealism through its
enigmatic concepts."

Perhaps it could be said that a tradition emerges in the
work of Frida Kahlo. For one of the particularities of the re-
tables, which is precisely their greatest charm, is that they not
only narrate impressive past events but, at the same time, ex-
press the magic behind the real event, the supernatural sense
of what happened: the miracle that was performed, thanks to
divine omnipotence, thanks to the mercy of the Virgin.

The revelation of the meaning of what happened is also
the visual expression of Frida Kahlo. A lot of retables even
have this visual expression—that placing of one next to the
other, in an area located beyond time and space, heteroge-
neous elements, linked in an internal relationship, not an ex-
ternal one. Of course, the intellectual difference of a creative
personality in the twentieth century is the lack of the imper-
turbable optimism that fills the painting of retables; it lacks,
first of all, the naivety of those popular artists, their naive
faith that accepts a miracle as the work of Divine Providence.
Frida's attitude is an interrogation, anguishing questioning,
and the wonder that a miracle is possible in a rational world.
Guided by astonishment and anguish, you can discover a

hidden stratum of life, buried under the realities of existence and made conscious and visible through creation. This is where her art coincides with surrealism, a contemporary effort, an intellectual effort, to decipher the painful, intimate adventures where the soul's anguish is born. But even this coincidence is not a classification, it is in order to place Frida Kahlo's creation somewhere. An internal clairvoyance acts within this artist, for whom the limits of the optically and rationally perceptible have ceased to exist. Frida does not intend to decipher the enigma of reality: she confesses, babbling her constant, her deep emotion at the incomprehensibility of life.

Frida Kahlo has painted many self-portraits. Again and again she has struggled to interpret herself. All those portraits are different. All are interrogations. Interrogations of the sense of existence, of the Universe, of man. Interrogations especially about the meaning and destiny of that human who is herself in the midst of the mystery of this universe.

THE LAST INTERVIEW: "FRAGMENTS OF THE LIFE OF FRIDA KAHLO"

INTERVIEW BY RAQUEL TIBOL
NOVEDADES: MÉXICO EN LA CULTURA
MARCH 7, 1954
TRANSLATED BY VIVIAN ARIMANY

It has been repeatedly said, and rightfully so, that Frida Kahlo's paintings are a brave and valuable testament to her own existence . . .

What existence has provoked art so alarming, touching, unique, hurtful, abundant, bristling, informant, austere, tragic, loving, heartbreaking, tender, meticulous, effective, chronicling, substantive, blissful?

I met Frida Kahlo one afternoon in May 1953 and for a few very short and intense days, I inhabited her candid universe. It was a time of extreme suffering for this beautiful woman.

Suffering dwells greedily in her. The afflictions exploded like the patterns of a stubborn and capricious juggler. Frida came through her pain, like a serene and heroic messenger, to tell fragments of her own story, and I had to assess my disbelief to know if I was able to understand her. Today, I reprint those fragments that I will one day develop in the "Imaginary Life of Frida Kahlo":

"I was born in Coyoacán, on the corner of Londres and Allende. My parents bought land that was part of the El Carmen farm and built their house there. My mother, Matilde Calderón y González, was the eldest child of twelve by my Spanish grandmother, Isabel, and my grandfather, a native of Morelia. My mother was friendly the wives, the children, and the old women who came to the house to pray the rosaries. She never lacked anything; she could always find five silver pesos in her dresser. She was a short woman, with very pretty eyes, a very thin mouth, and brown hair. When she went to the market, she gracefully cinched her girdle and flirtatiously carried her basket. She was very likeable, active, intelligent. She could not read or write: she only knew how to count money. She died young, at fifty-six years old.

"My father, Guillermo Kahlo, was a fascinating man, quite elegant when moving, when walking. He was calm, hardworking, brave, and a man of few friends. He only had two friends. One was an old, heavy man, who always forgot his hat on top of the wardrobe. My father and the old man spent hours playing chess and drinking coffee. My father was born in Wiesbaden, Germany, but of Hungarian parents. He studied in Nuremberg. His mother died when he was eighteen years old. He did not like his stepmother, so his father, who was a jeweler, gave him enough money to come to America. He arrived when he was nineteen; since then he had frequent epileptic seizures. At twenty-three he married. He had two daughters from this first marriage: María Luisa and Margarita. His first wife died giving birth to Margarita. The night his wife died, my father called my grandmother Isabel, who arrived with my mother. She and my father worked in

the same store; they really trusted each other. He was very much in love with her and later married her.

"María Luisa was seven years old and Margarita three, when they were admitted into the Tacuba convent. Margarita became a nun. Maria Luisa was married by the nuns through letters to a man named Jalisco. María Luisa has always been a very hardworking girl; she never asked for a dime. She lives in a room for which she pays forty-five pesos monthly. She is neither self-destructive nor a liar; just like my father.

"My grandfather Calderón was a photographer, which is why my mother convinced my father to become a photographer. His father-in-law lent him a camera and the first thing my parents did was go on tour through the republic. They took a collection of photos of indigenous and colonial architecture and returned, setting up their first office on the Avenida 16 de Septiembre, which is a lot to say! From then on was a difficult time in my house.

"I physically resemble both of my parents. I have my mother's eyes and my father's body.

"My mother could not breastfeed me because eleven months after I was born, my sister Cristina was born. I was nursed by wet nurse who would wash her breasts each time I went to suck them. I appear in one of my paintings with a woman's face and a little girl's body, lying in my nurse's arms, while milk falls from her nipples as if from the sky.

"Between the ages of three and four, Cristi and I were sent to a nursery school. The teacher was from olden times, with fake hair and bizarre outfits. My first memory refers precisely to said teacher. She was standing in front of the pitch-dark room, holding a candle in one hand and in the other an

orange, explaining what the universe was like, the sun, the earth and the moon. I peed from the effect, they took off my wet panties and changed them for those of a girl who lived in front of my house. Because of this I developed such hatred towards her that one day I brought her to my house and began to choke her. I already had my tongue out when a baker passed by and pulled her from my grasp.

"Then I took part in religious rituals. At six years old I took the First Communion. For a whole year they made us, Cristi and I, attend the teachings, but we would run away and go eat tejocotes, membrillos, and capulines in a nearby garden.

"One day, my half-sister, Maria Luisa, was sitting on the chamber pot when I pushed her and she fell backwards with the pot and everything. Furious, she said to me: 'You are not my mother and father's daughter. You were picked up from a dumpster.' Such a statement impacted me to the point of becoming a completely introverted child. From then on, I lived through adventures with an imaginary friend. I would look for her in the shop where the display cases had the word PINZON written on the glass in large letters. I would mist of my breath onto the window, and form an O, a little door that took me to the center of the earth. There my friend always waited for me, so we could play together.

"At six I developed polio. I remember everything clearly since then. I spent nine months in bed. It all started with a horrible pain in my right leg from the thigh down. They washed my little leg in a tin with walnut water and warm cloths. My leg became notably thin. At seven I began wearing

little boots. At first I expected that the teasing would not bother me, but then it began to bother me more and more.

"At seven I helped my sister Matilde, who was fifteen at the time, run away to Veracruz with her boyfriend. I opened the veranda and then closed it as if nothing had happened. Matita was my mother's favorite and her escape made her hysterical. Why didn't Matita run away? My mother was hysterical because of her own dissatisfaction. I found it repugnant watching her take mice out of the basement and drown them in a barrel. She wouldn't let them go until they were completely drowned. This affected me in tremendous ways. I would say to her crying: 'Oh, Mother, how cruel you are!' Perhaps she was cruel because she wasn't in love with my father. When I was eleven, she showed me a Russian-leather book where she kept letters from her first boyfriend. On the last page of it was written that the author of the letters, a young German man, had committed suicide in her presence. That man always lived in her memory. I gave Cristi the Russian leather-bound book.

"My mother was a great friend to me, but the whole religious thing never united us. My mother went down in history for religion. We had to pray before every meal. While everyone else focused on themselves, Cristi and I would make eye contact, struggling to contain our laughter . . . For twelve years my mother won the battle against me, but by thirteen I was already a raging leftist.

"When Mati left, my father didn't say a word. He was so calm that it was difficult for me to remember his epilepsy. Even though I had to escort him to his chamber many times,

[his] arm around my shoulders and holding my hand as he tripped repeatedly. I learned to assist him during his attacks on the street. First, I made sure he promptly inhaled ether or alcohol, and then, I made sure no one stole his camera.

"For four years we never saw Matita. One day, while traveling by tram, my father exclaimed: 'We will never find her!' I comforted him, and in truth, my hope was genuine.

"I was twelve years old when a high school classmate told me: 'On the doctor's street there's a woman who looks just like you. Her name is Matilde Kahlo.'

"At the end of a courtyard, in the fourth room of a long corridor, I found her. It was a room full of light and birds. Matita was bathing with a hose. She lived there with Paco Hernández, whom she later married. They enjoyed a good financial situation and had no children. The first thing I did was tell my father that I had found her. I visited her several times and tried to convince my mother to see her, but she didn't want to . . .

"My toys were boy toys: skates, bicycles. Since my parents were not rich, I had to work in a lumberyard. My job was to control how many beams came out per day, how many went in, what their color was, and what their quality was. I worked in the afternoon and in the morning I went to school. They paid me seventy-five pesos a month, of which I did not use a penny. Before the bus crushed me I wanted to be a doctor.

"The buses of my time were flimsy things; when they began to circulate they were very successful; the trams were empty. I got on the bus with Alejandro Gómez Arias. I sat on the corner, next to the handrail and Alejandro was next to me. Moments later the bus collided with a tram of the

Xochimilco line. The tram crushed the bus against the corner. It was a strange shock; it was not violent, but it was deaf, slow, and dreadful for everyone. And to me much more. I remember that it happened exactly on September 17, 1926, the day after the holidays of the sixteenth. I was sixteen at the time, but looked much younger, even younger than Cristi, despite being eleven months older than her.

"Soon after getting onto the bus, the crash started. Before that we had gotten on a different bus, but I had lost an umbrella so we went to look for it and that is how we came to get on the one that destroyed me. The accident happened on a corner, in front of the San Juan market, exactly opposite it. The tram was marching slowly, but our bus driver was a very nervous young man. The tram, when turning, dragged the bus against the wall.

"I was an intelligent little girl but impractical, despite the freedom I had won. Maybe that's why I didn't gauge the situation or realize the gravity of injuries I had. The first thing I thought about was a beautifully colored ball that I had bought that day and I had with me. I tried looking for it, believing that all this would not have major consequences.

"While in shock from the crash, it is a lie that I cried. I shed no tears. The crash pushed us forward and the handrail pierced me like a bull's sword. A man saw me with a tremendous hemorrhage carried me and placed me on a pool table until the Red Cross picked me up.

"I lost my virginity, and my kidney softened, I couldn't urinate, and what bothered me most was my spine. I was not taken care of properly and I had no X-rays taken. I sat down as best I could and told the Red Cross to call my family.

Matilde read the report in the newspapers and was the first to arrive and did not leave for three months; she was by my side day and night. My mother was silent for a month because of the effect and did not come to see me. My sister Adriana, when she found out, fainted. My father was so upset that he got sick and I could only see him after twenty days. There had never been deaths in my house.

"I spent three months in the Red Cross. The Red Cross was very poor. They had us in a kind of awful shed, the food was crap and could hardly be eaten. A single nurse took care of twenty-five patients. It was Matilde who raised my spirits; she would joke with me. She was fat and fairly ugly, but she had a great sense of humor. She could make everyone in the room laugh. She knitted and helped the nurse care for the sick. My high school classmates would come visit me. They brought me flowers and tried to distract me. They were the members of 'Los Cachuchas,' an all-boy group whose only female member was me. One of them gave me a doll that I still have. I kept that doll and many other things. I love things, life, and people. I don't want people to die. I do not fear death, but I want to live. Pain, however, I cannot bear.

"As soon as I saw my mother, I told her: 'I have not died and, besides, I have something to live for.'

"That something was painting. Since I was had to be lying down with a plaster cast that went from my collarbone to my pelvis, my mother cleverly made a quite peculiar device that held the wood that supported my papers. It was my mother who had the idea to roof my Renaissance-style bed in order to place a mirror the entire length so I could see myself and use my image as a model.

"After spending a year cast in different corsets, I began to frequent the Ministry of Education, where Diego was painting his murals. I had a tremendous desire to paint al fresco. I showed Diego the work I had done, and he said: 'You must transform your will into its purest expression.'

"Then I started painting things he did like. He has admired me since then, he loves me. For a very short time I stuck to his painting. Then I worked really hard to ensure they were well done. The first three works I painted have the same themes as Diego: a swollen woman, a boy sitting on a bench, a girl sitting in a palm chair. Of the paintings I made, the ones I like the most are: *My Nurse and I, The Love Embrace of the Universe, the Earth, Myself, and Diego*, and the portrait of engineer Morillo Safa's mother. My first exhibition was held at the Julien Levy Gallery in New York in 1938. The first painting I sold was acquired by Jackson Phillips. The engineer Morillo Safa acquired most of my work.

"My paintings are well painted; not swiftly, but patiently. My paintings carry the message of pain. I think, at least a few people are interested in that. My work is not revolutionary, why do I continue to have illusions that it is combative? I cannot. Painting fulfills my life. I lost three children and a number of other things that would have filled my horrible life. All that was replaced by painting, which I think is for the best."

FRIDA KAHLO (1907–1954) is considered one of Mexico's greatest painters. Drawing inspiration mainly from Mexican folk culture, Kahlo is known for her many self-portraits that mixed fantasy and reality and often incorporated personal and social commentary. Her work was shown in Paris, New York, and Mexico before her death in 1954. Kahlo's work went largely unnoticed outside of Mexico until the 1970s, when she was rediscovered by art historians and political activists. Since then she has been the subject of numerous biographies and retrospectives.

HAYDEN HERRERA is an art historian, critic, and biographer. Her doctoral dissertation about Frida Kahlo became her first book: *Frida: A Biography of Frida Kahlo.* Her other biographies include Pulitzer Prize nominee *Arshile Gorky: His Life and Work* and *Listening to Stone: The Art and Life of Isamu Noguchi*, which won the Los Angeles Times Book Prize. Hayden has contributed articles and reviews to such publications as *Art in America*, *Art Forum*, and the *New York Times*. She has lectured widely, taught art history at the School of Visual Arts and at New York University, and curated several exhibitions, among them a Frida Kahlo exhibition that toured US museums in 1978 and a traveling Frida Kahlo centennial exhibition that opened at the Walker Art Center in 2008. Hayden lives and works in New York City.

FLORENCE DAVIES was an art critic at the *Detroit News* for over a decade. Her papers are held in the Archives of American Art at the Smithsonian Institution.

BERTRAM D. WOLFE (1896–1977) was a scholar, former communist, and one of the foremost experts on the Soviet Union in the United States during the Cold War. One of the founders of the Communist Party of the United States, he was eventually expelled from the party for his early criticism of Stalin. In 1933 Wolfe and his wife, Ella, lived with Diego Rivera and Frida Kahlo during which time he coauthored two books with Rivera. In 1963 Wolfe published *The Fabulous Life of Diego Rivera.* At the time of his death, Wolfe was a senior fellow at the Hoover Institution on War, Revolution, and Peace.

GEOFFREY T. HELLMAN (1907–1977) was a reporter for the *New Yorker* "Talk of the Town" section. Hellman wrote extensively about New York institutions to promote public awareness of these institutions

and of interesting events they sponsored. He also wrote about prominent people such as author Louis Auchincloss and architect Frank Lloyd Wright. His books include compilations of his pieces that appeared in the *New Yorker, Octopus on the Mall,* and *Bankers, Bones, and Beetles.* From 1936–1938, he was the associate editor of *LIFE* magazine. During World War II, Hellman was in Washington D.C. where he wrote for the Office of Inter-American affairs and the War Department and helped to write a top-secret history of the Office of Strategic Services.

HAROLD ROSS (1892–1951) was a journalist who co-founded the *New Yorker* in 1925 and served as its editor in chief from its inception until his death. By the time Ross was twenty-five he has worked as a reporter for at least seven newspapers across the country, and during World War I, he edited a regimental journal in France and worked for the *Stars and Stripes* in Paris from February 1918 to April 1919. After returning to New York City and editing several magazines, Ross imagined the *New Yorker* as a journal with a more metropolitan tone and sophisticated style. Ross attracted talented young new writers and artists, who were drawn to the *New Yorker* by its innovative style and Ross's passion for good writing rather than big names. His correspondence is held at the New York Public Library.

MARIO MONTEFORTE TOLEDO (1911–2003) was a Guatemalan writer, dramatist and politician. He served played an important role in the governments of both Juan José Arévalo and Jacobo Árbenz. After the fall of the Árbenz administration, Monteforte lived in exile for thirty-five years with stays in Mexico, France, and the United States. In 1993 Monteforte was awarded the Guatemala National Prize in Literature for his overall body of work and is considered one of Guatemala's most important writers.

GISÈLE FREUND (1908–2000) was a German-born French photographer and photojournalist. She is best known for her portraits of literary elite and early adoption of color photography. As a photojournalist Freund worked with Magnum, *LIFE,* and *Time* magazine. In 1952 Freund travelled to Mexico and photographed Frida Kahlo and Diego Rivera. In 1980 she was awarded the National Grand Prize for Photography in France and was made a knight of the Legion of Honour in 1983. Freund is recognized as one of the great portrait photographers of the twentieth century.

PAUL WESTHEIM (1886–1963) was a German art critic and publisher of the German art magazine *Das Kunstblatt*. Westheim was an early supporter of expressionism and gathered an important collection on German Expressionist art. The rise of the Nazi party forced him to flee to Paris, where he was arrested during the Nazi occupation. After being sent to multiple concentration camps Westheim escaped and arrived in Mexico in 1942. There he began studying and writing on Mesoamerican and modern Mexican art. He remained in Mexico until his death.

RAQUEL TIBOL (1923–2015) was a critic and historian of Mexican art, a curator, and a journalist. Born in Argentina, she lived moved to Mexico in 1953 and quickly established herself as a formidable and controversial art critic. Working as Diego Rivera's secretary, Tibol became close to the couple and a confidante for Frida Kahlo. Tibol authored over forty books including several on Kahlo. The recipient of Premio de Periodismo Cultural Fernando Benítez (1998), la Medalla de Oro de Bellas Artes, and an honorary doctorate from the Universidad Autónoma Metropolitana, Tibol is considered one of the most important art critics in Mexico.

VIVIAN ARIMANY hails from Guatemala and moved to New York City after college. Her bilingual poetry pamphlet "Irrevocable Conditions" was published in Guatemala by Fundación Yaxs. She has been a writer for *Latin American News Digest* and she is pursuing graduate studies in Hispanic literatures. This is her first formal translation credit.

THE LAST INTERVIEW SERIES

KURT VONNEGUT: THE LAST INTERVIEW

"I think it can be tremendously refreshing if a creator of literature has something on his mind other than the history of literature so far. Literature should not disappear up its own asshole, so to speak."

$15.95 / $17.95 CAN
978-1-61219-090-7
ebook: 978-1-61219-091-4

JACQUES DERRIDA: THE LAST INTERVIEW
LEARNING TO LIVE FINALLY

"I am at war with myself, it's true, you couldn't possibly know to what extent... I say contradictory things that are, we might say, in real tension; they are what construct me, make me live, and will make me die."

translated by PASCAL-ANNE BRAULT and MICHAEL NAAS

$15.95 / $17.95 CAN
978-1-61219-094-5
ebook: 978-1-61219-032-7

ROBERTO BOLAÑO: THE LAST INTERVIEW

"Posthumous: It sounds like the name of a Roman gladiator, an unconquered gladiator. At least that's what poor Posthumous would like to believe. It gives him courage."

translated by SYBIL PEREZ and others

$15.95 / $17.95 CAN
978-1-61219-095-2
ebook: 978-1-61219-033-4

THE LAST INTERVIEW SERIES

JORGE LUIS BORGES: THE LAST INTERVIEW

"Believe me: the benefits of blindness have been greatly exaggerated. If I could see, I would never leave the house, I'd stay indoors reading the many books that surround me."

translated by KIT MAUDE

$15.95 / $15.95 CAN
978-1-61219-204-8
ebook: 978-1-61219-205-5

HANNAH ARENDT: THE LAST INTERVIEW

"There are no dangerous thoughts for the simple reason that thinking itself is such a dangerous enterprise."

$15.95 / $15.95 CAN
978-1-61219-311-3
ebook: 978-1-61219-312-0

RAY BRADBURY: THE LAST INTERVIEW

"You don't have to destroy books to destroy a culture. Just get people to stop reading them."

$15.95 / $15.95 CAN
978-1-61219-421-9
ebook: 978-1-61219-422-6

THE LAST INTERVIEW SERIES

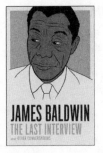

JAMES BALDWIN: THE LAST INTERVIEW

"You don't realize that you're intelligent until it gets you into trouble."

$15.95 / $15.95 CAN
978-1-61219-400-4
ebook: 978-1-61219-401-1

GABRIEL GÁRCIA MÁRQUEZ: THE LAST INTERVIEW

"The only thing the Nobel Prize is good for is not having to wait in line."

$15.95 / $15.95 CAN
978-1-61219-480-6
ebook: 978-1-61219-481-3

LOU REED: THE LAST INTERVIEW

"Hubert Selby. William Burroughs. Allen Ginsberg. Delmore Schwartz... I thought if you could do what those writers did and put it to drums and guitar, you'd have the greatest thing on earth."

$15.95 / $15.95 CAN
978-1-61219-478-3
ebook: 978-1-61219-479-0

THE LAST INTERVIEW SERIES

ERNEST HEMINGWAY: THE LAST INTERVIEW

"The most essential gift for a good writer is a built-in, shockproof shit detector."

$15.95 / $20.95 CAN
978-1-61219-522-3
ebook: 978-1-61219-523-0

PHILIP K. DICK: THE LAST INTERVIEW

"The basic thing is, how frightened are you of chaos? And how happy are you with order?"

$15.95 / $20.95 CAN
978-1-61219-526-1
ebook: 978-1-61219-527-8

NORA EPHRON: THE LAST INTERVIEW

"You better *make* them care about what you think. It had better be quirky or perverse or thoughtful enough so that you hit some chord in them. Otherwise, it doesn't work."

$15.95 / $20.95 CAN
978-1-61219-524-7
ebook: 978-1-61219-525-4

THE LAST INTERVIEW SERIES

JANE JACOBS: THE LAST INTERVIEW

"I would like it to be understood that all our human
economic achievements have been done by
ordinary people, not by exceptionally educated
people, or by elites, or by supernatural forces."

$15.95 / $20.95 CAN
978-1-61219-534-6
ebook: 978-1-61219-535-3

DAVID BOWIE: THE LAST INTERVIEW

"I have no time for glamour. It seems a ridiculous
thing to strive for... A clean pair of shoes should
serve quite well."

$16.99 / $22.99 CAN
978-1-61219-575-9
ebook: 978-1-61219-576-6

MARTIN LUTHER KING, JR.:
THE LAST INTERVIEW

"Injustice anywhere is a threat to justice
everywhere."

$15.99 / $21.99 CAN
978-1-61219-616-9
ebook: 978-1-61219-617-6

THE LAST INTERVIEW SERIES

CHRISTOPHER HITCHENS: THE LAST INTERVIEW

"If someone says I'm doing this out of faith, I say,
Why don't you do it out of conviction?"

$15.99 / $20.99 CAN
978-1-61219-672-5
ebook: 978-1-61219-673-2

HUNTER S. THOMPSON: THE LAST INTERVIEW

"I feel in the mood to write a long weird story—a tale
so strange and terrible that it will change the brain
of the normal reader forever."

$15.99 / $20.99 CAN
978-1-61219-693-0
ebook: 978-1-61219-694-7

DAVID FOSTER WALLACE: THE LAST INTERVIEW AND OTHER CONVERSATIONS

"I'm a typical American. Half of me is dying to give
myself away, and the other half is continually
rebelling."

$16.99 / 21.99 CAN
978-1-61219-741-8
ebook: 978-1-61219-742-5

THE LAST INTERVIEW SERIES

KATHY ACKER: THE LAST INTERVIEW AND OTHER CONVERSATIONS

"To my mind I was in a little cage in the zoo that instead of 'monkey' said 'female American radical.'"

$15.99 / $20.99 CAN
978-1-61219-731-9
ebook: 978-1-61219-732-6

PRINCE: THE LAST INTERVIEW AND OTHER CONVERSATIONS

"That's what you want. Transcendence. When that happens—oh, boy."

$16.99 / $22.99 CAN
978-1-61219-745-6
ebook: 978-1-61219-746-3

JULIA CHILD: THE LAST INTERVIEW AND OTHER CONVERSATIONS

"I'm not a chef, I'm a teacher and a cook."

$16.99 / $22.99 CAN
978-1-61219-733-3
ebook: 978-1-61219-734-0

THE LAST INTERVIEW SERIES

URSULA K. LE GUIN: THE LAST INTERVIEW AND OTHER CONVERSATIONS

"Resistance and change often begin in art.
Very often in our art, the art of words."

$16.99 / $21.99 CAN
978-1-61219-779-1
ebook: 978-1-61219-780-7